P E N G U I N    B

# Oh My Goddess!

Sally Swain was born in Sydney, Australia in 1958. At age three she painted people with large bellybuttons. At age five she began an illustrated journal.

Swain later studied psychology, then wondered why. She worked as a research assistant, community worker, teacher, illustrator and a not-very-good waitress.

She has three children—the adolescents, *Great Housewives of Art* and *Great Housewives of Art Revisited*, and the toddler, *Oh My Goddess!*

Swain has discovered a love of facilitating creativity in others and she runs art experience workshops.

She enjoys eating and tries to enjoy cooking.

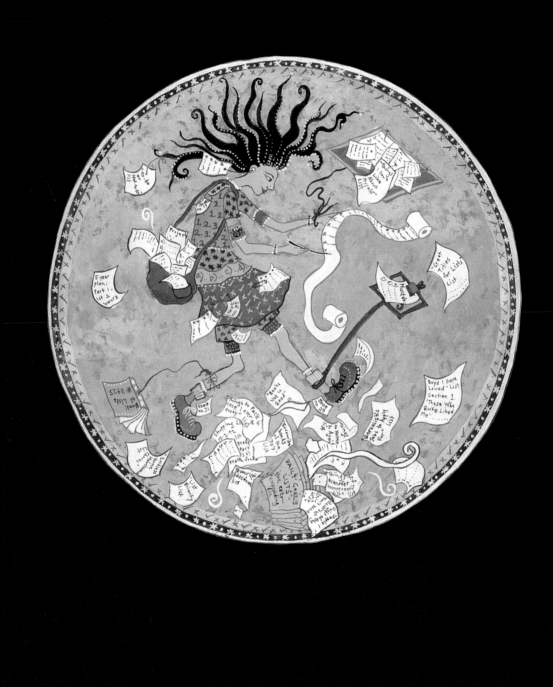

# OH MY GODDESS!

*Sally Swain*

**PENGUIN BOOKS**

PENGUIN BOOKS
Published by the Penguin Group
Penguin Books USA Inc., 375 Hudson Street,
New York, New York, 10014, U.S.A.
Penguin Books Ltd, 27 Wrights Lane,
London W8 5TZ, England
Penguin Books Australia Ltd, Ringwood, Victoria, Australia
Penguin Books Canada Ltd, 10 Alcorn Avenue,
Toronto, Ontario, Canada M4V 3B2
Penguin Books (N.Z.) Ltd, 182-190 Wairau Road, Auckland 10, New Zealand

Penguin Books Ltd, Registered Offices: Harmondsworth, Middlesex, England

First published in Penguin Books 1994

1   3   5   7   9   10  8   6   4   2

LIBRARY OF CONGRESS CATALOGING IN PUBLICATION DATA
Swain, Sally.
Oh my goddess!/Sally Swain.
p.   cm.
ISBN 0 14 02.3383 0
1. Goddesses in art.   2. Australian wit and humor, Pictorial.   I. Title.
NC1759.S93A4   1994
741.5'994—dc20      94-14757

ISBN 0 14 02.3383 0
(CIP data available)

Printed in the United States of America
Set in Gill Sans Light
Designed by Katy Riegel

For
the creative and
nurturing power
within us all—may
we find marvelous
ways of tapping into
it while retaining
a sense of
frivolity.

# Acknowledgments

Thank you to Mum, Dad, Jennie and Stu whose love and support nourish the tree of my artistic expression and whose skepticism stops me getting too mushy.

In particular, thanks to Jen for helping to dream up this project, for her inspiration, laughter and idea playshops. Thanks to Dad for the title and editing; Stu for editing and for being there along the way and Mum for the Family Tree of Life.

Thanks to friends who participated in the process, particularly Jesse, Sue F., Leanne and Sue C. Also to agents and publishers Tim, Fiona, Henry, Anthea, Judith and Dawn.

Oh my Goddess! Have I forgotten anyone?

I thank all those whose play and work keep the sacred feminine alive.

# A Few Words from the Great Goddess

I don't like to brag, but I gave birth to the world.

No need for applause.
I had that in my heyday, quite a few years back.
From about 6,000 to 30,000 years ago I was a star.
More of a moon, actually.
They paid more attention to the moon back then.
They also respected the bodies and souls of women, the Earth and
   the cycle of life, death and rebirth.

I birthed the world from the darkness of my womb.
From my own body I created the Earth which *was* my body.

People cupped in their hands small earth and stone sculptures of
   me, for worship.
They smeared red ochre on these sculptures and at cave entrances,
   to represent the blood of birth, menstruation, and death.
When anything died—plant, animal, human, emotion, political
   movement—it returned to my deep dark cave womb to be
   reborn in a different form.
Sort of recycling.

Speaking of which, you should see a picture of Greena, one of my
   talented granddaughters.
She helps to resprout my energy by recycling modern goddess
   symbols.

I must also show you the Great Goddess Family Tree of Life and a
   Time Spiral to give you an idea of goddess herstory.
Then, why not look through a family album?

My girls keep me going.
Many people have tried to destroy me.
The attacks began with violent invasions of goddess cultures around
    4,500 B.C.E. (Before Common Era) and continue in subtler, more
    disguised forms today.

However, my essence has been kept alive.
From the Virgin Mary to Cinderella, from fairy godmothers and
    wicked witches to midwives, medicine makers, menstruaters,
    Marilyn Monroe, Mother Theresa and Madonna.
From the Goddess of Wisdom to Documentia, Goddess of Lists.
From the Goddess of Fertility to Pramh, Goddess of Babies.
From the Goddess of Healing to Aquaria, Goddess of the Float
    Tank.

My daughters and granddaughters maintain and renew my spirit.

Sadly, my power has been distorted by a sick society.
Sometimes I'm acutely aware of this.
My daughter, the Goddess of Peace, gave birth to a Goddess of
    Minor Tranquilizers. The Goddess of Fortune gave birth to a
    Commuter.

My granddaughters manifest my ever-decreasing powers.
I weep Great Goddess tears.

But I remind myself that these granddaughters of mine are never-
    theless GODDESSES.
I meditate on each image in the family album.
I ask myself "What is the value of this particular goddess?"

Reading romantic fiction, watching soap operas, writing lists and
    drinking tea are all valid activities in themselves, are they not?

I call this simple, active meditative process GODDESSIFICATION.

It helps me respect and accept these modern goddesses and the way they live their lives.
I can reclaim the worth of trivial-seeming human pursuits.
I can then rediscover my own power in this funny old new world.

If you're a bit down in the dumps or out of touch, I recommend a good goddessifying session for affirming your own feelings, beliefs and everyday actions that link you with past goddess tradition.

For example, Dialtonic presides over the telephone. Waste of time? Idle women's gossip?
A few moments of goddessification reveals telephone talk as a valuable form of communication.
We impart information, share insights and feelings, validate ourselves and connect with others through chatting on the phone.
It's a contemporary way of keeping ancient oral traditions alive.

Connectedness is important in Goddess spirituality—connection with the planet, all living things and even different aspects of ourselves. Look at Thorax's connection with animals, Greena's with the earth, Fallopia's with the moon.

How about another glimpse at goddessification? Leotardia takes care of aerobics. Commonplace and lowly?
Think of Leotardia's ritual repetition of movements in a community setting.
This makes her feel healthier, more alive, more in touch. Performance of ritual, being earthed, being in the body and in a community are attributes of the Goddess world-view. Don't we pursue ritual to fulfill deep-seated spiritual needs, to fill a gap left by lack of meaning in our lives?

Look at Obexity and Consumania—two daughters of the Goddess of Plenty. Are they obsessive and self-destructive, or do they

engage in self-nourishing contemporary rituals, linking them with ancient needs?

There's so much to be learned from the past for the present and future.

Enough for now. You might want to participate in a bit of active goddessification yourself.
Or just browse through the family album.

# OH MY GODDESS!

# Great Goddess Family Tree of Life

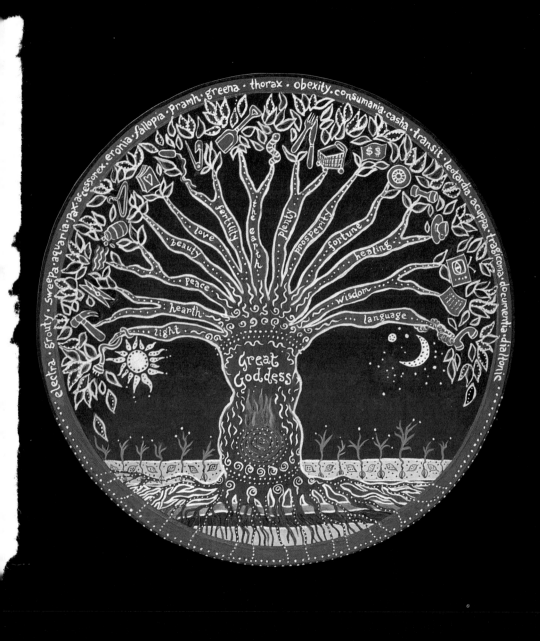

# Time Spiral

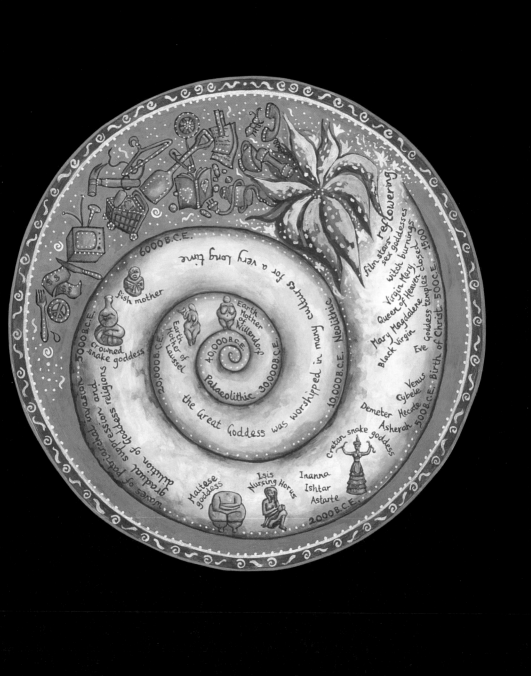

reflowering

film stars
sex goddesses
witch burnings
Virgin Mary 1500
Queen of Heaven closed
Mary Magdalene temples
Black Virgin

Eve Goddess 500 C.E.
Birth of Christ

Venus
Cybele
Demeter Hecate 500 B.C.E.
Asherah

cretan snake goddess

6000 B.C.E.

fish mother

Earth
Mother
of Willendorf
Earth
Mother of
Laussel

40,000 B.C.E.

Palaeolithic

the Great Goddess was worshipped for a very long time

Neolithic 10,000 B.C.E.

Goddess was worshipped in many cultures

crowned
snake goddess

5000 B.C.E.

20,000 B.C.E.

30,000 B.C.E.

waves of patriarchal invasion
and gradual suppression of goddess religions

Maltese
goddess

Isis
Nursing Horus

Inanna
Ishtar
Astarte

2000 B.C.E.

# Electra, Goddess of the Appliance

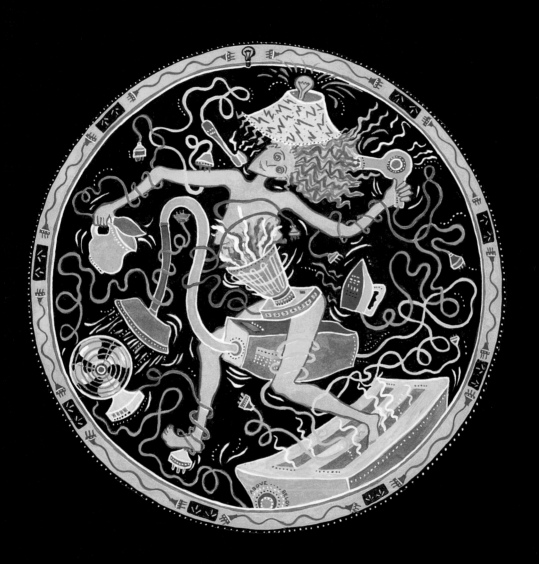

# Grouty, Goddess of Home improvement

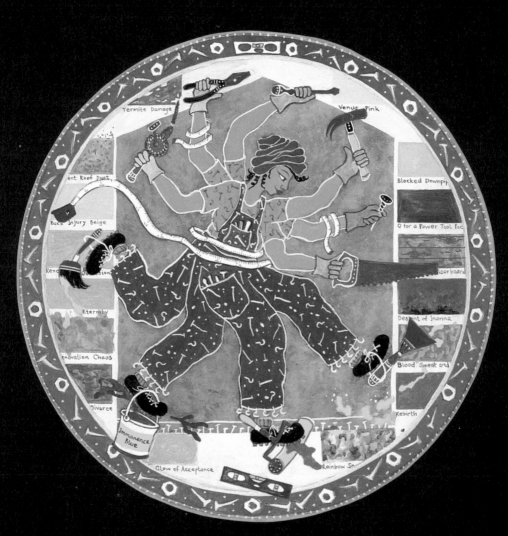

# Sweepa, Goddess of Housework and Purity

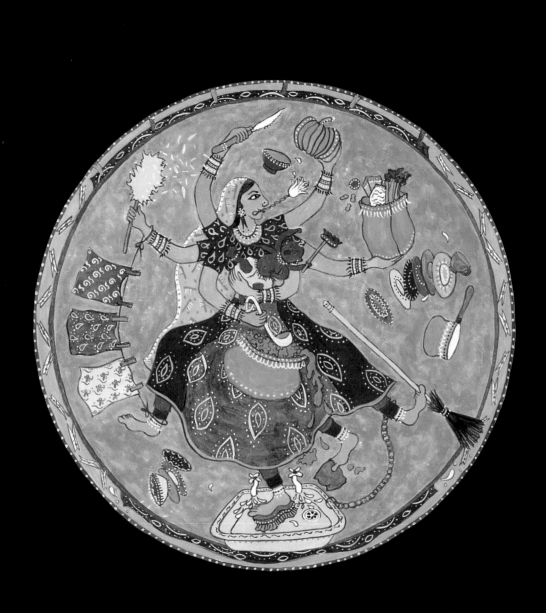

# Aquaria, Goddess of the Float Tank

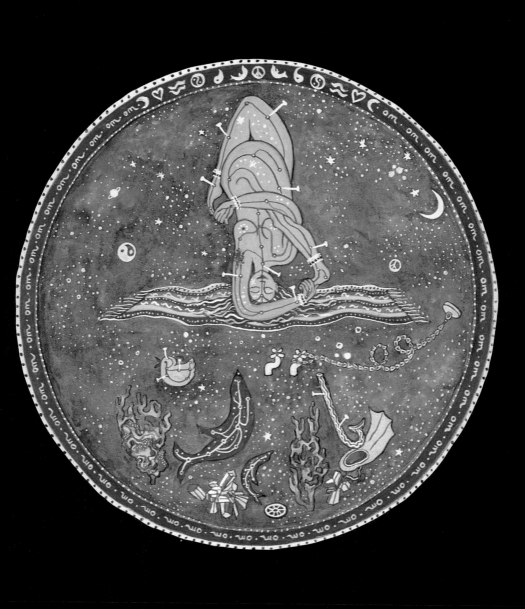

~~~~~~~~~~~~~~~~~~~~

# Pax,
# Goddess of
# Tranquilizers

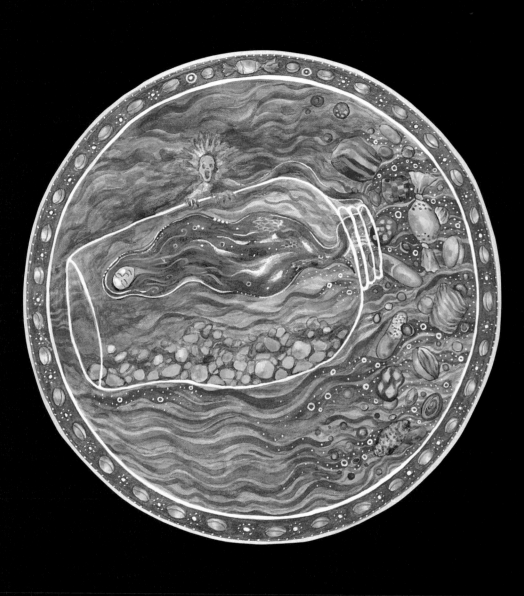

Accessorex,
Goddess of
Fashion

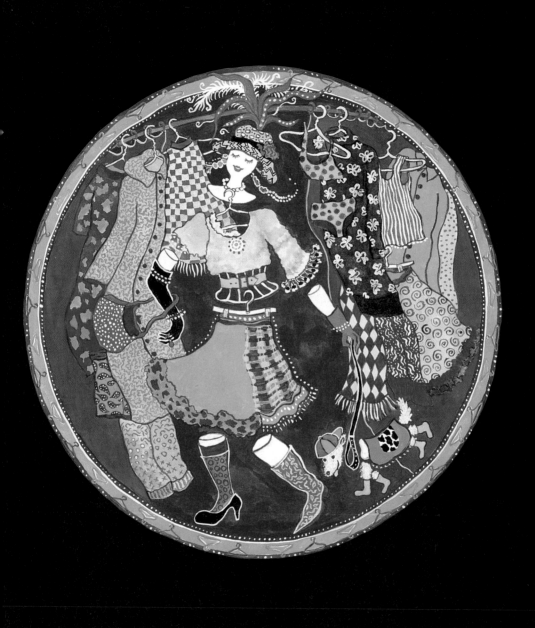

# Eronia, Goddess of Romantic Fiction

# Fallopia, Goddess of the Tampon

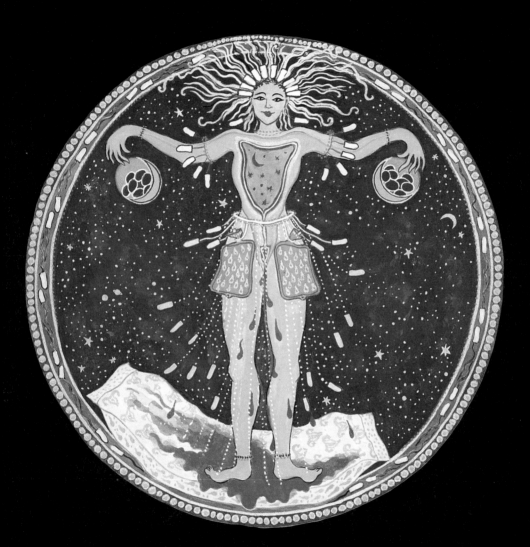

# Pramh,
# Goddess of
# Babies

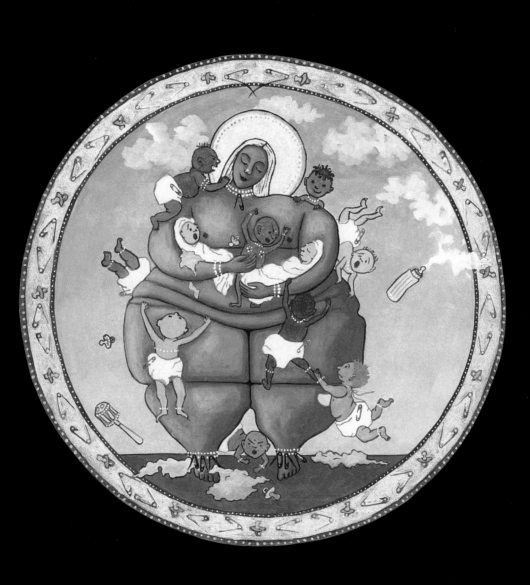

DAUGHTERS OF
THE GODDESS OF THE EARTH

# Greena, Goddess of Recycling

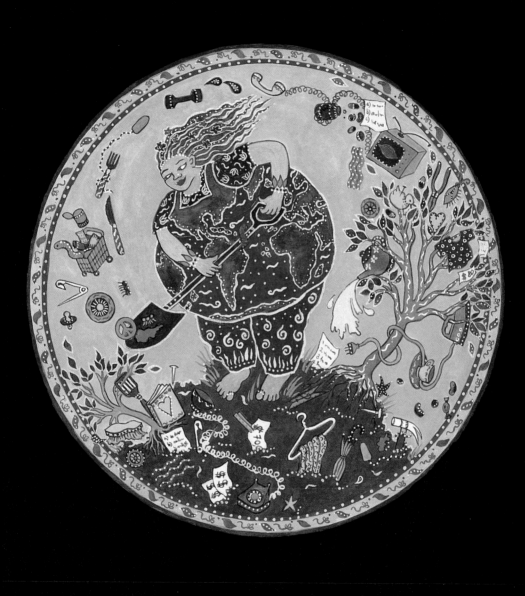

# Thorax, Goddess of Pest Management

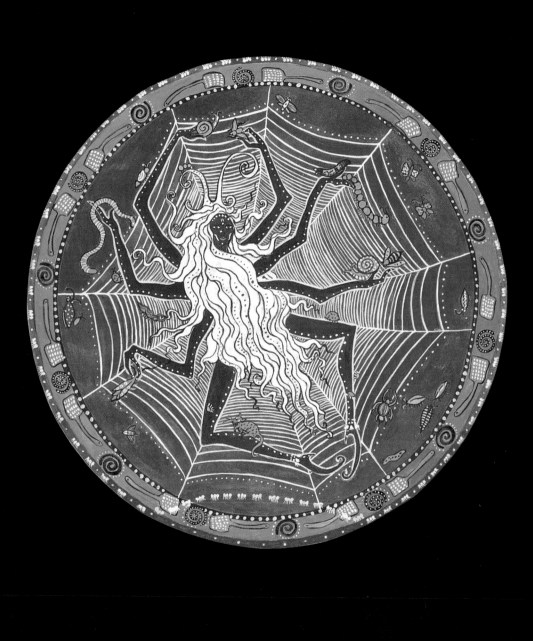

# Obexity,
# Goddess of
# Eating

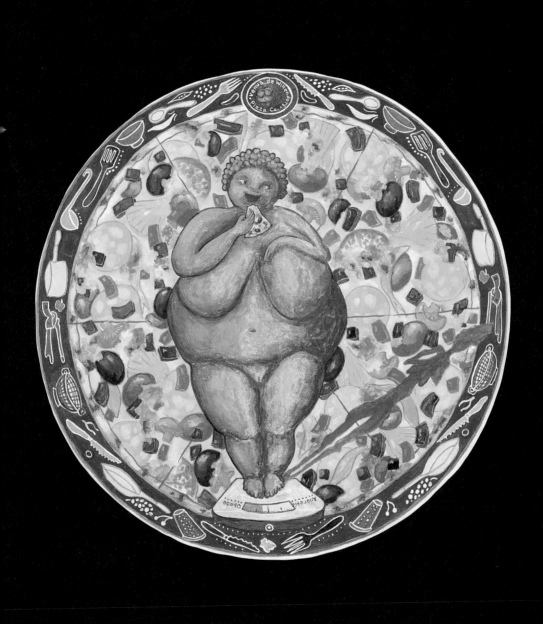

# Consumania,
# Goddess
# of the
# Supermarket

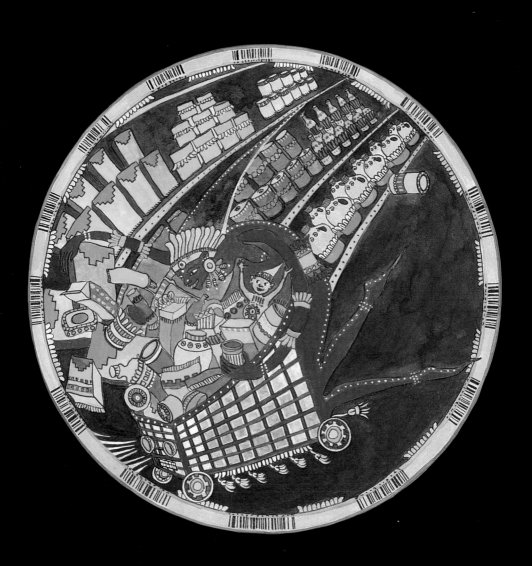

# Casha, Goddess of Automatic Banking

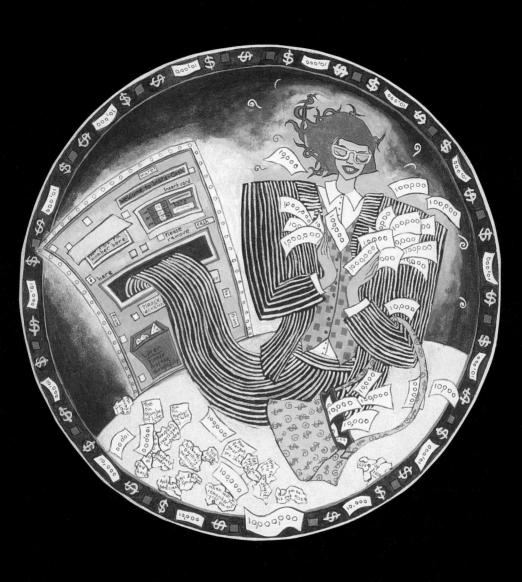

# Transit, Goddess of Commuting

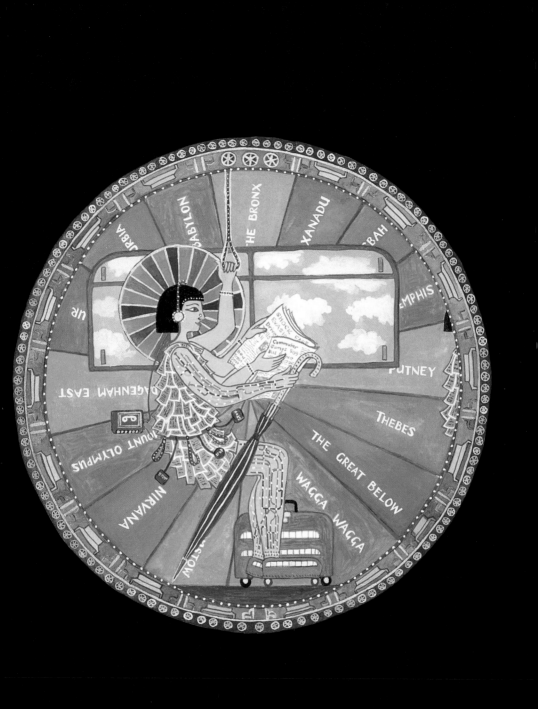

# Leotardia, Goddess of Aerobics

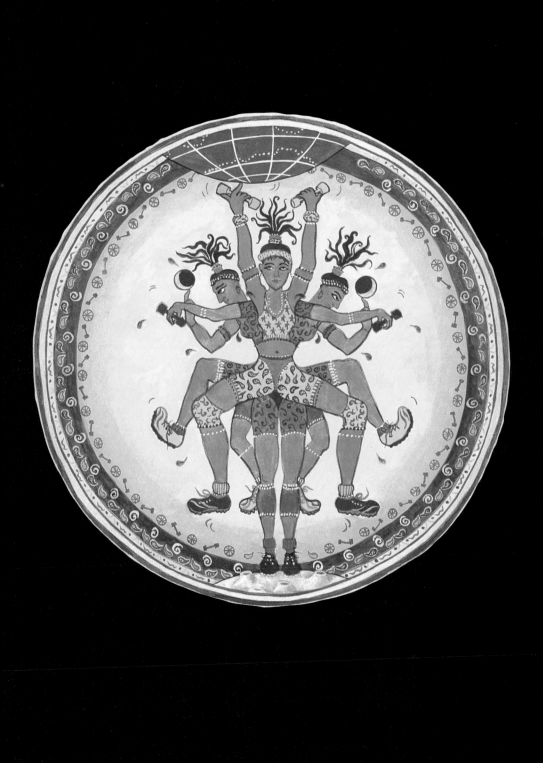

~~~~~~~~~~~~~~~~~~~~

# Acuppa,
# Goddess of
# Tea

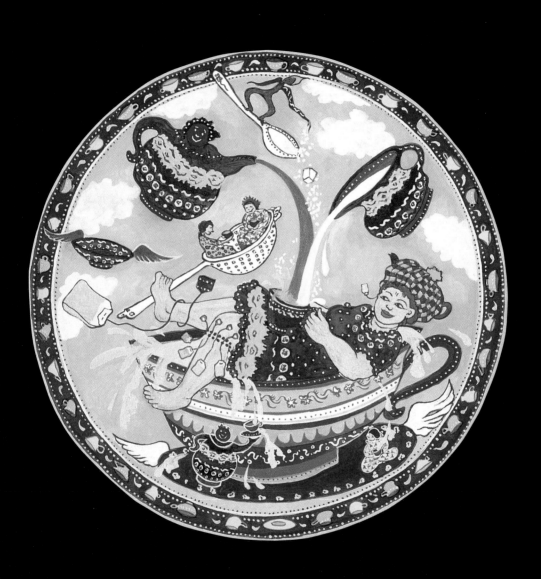

~~~~~~~~~~~~~~~~~~~~~~~~~~

# Tragicoma, Goddess of Soap Operas

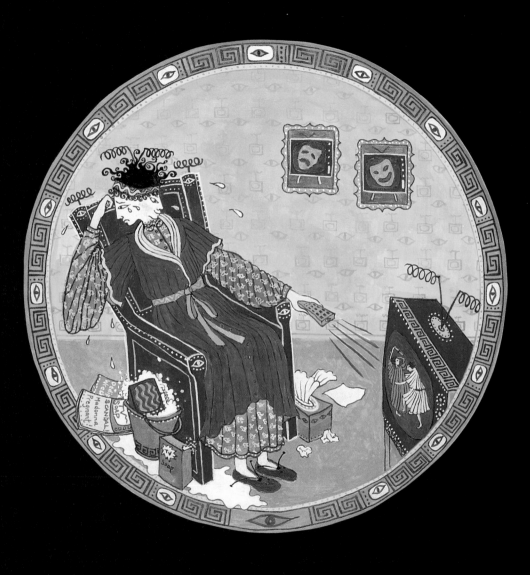

~~~~~~~~~~~~~~~~~~~~~~~~~~~~

# Documentia, Goddess of Lists

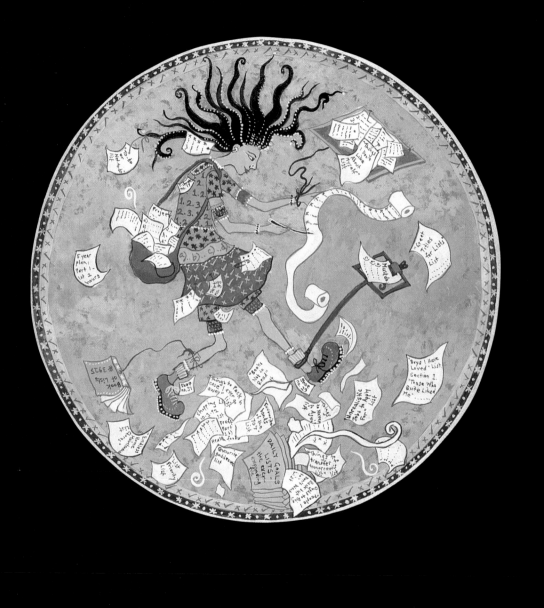

# Dialtonic,
# Goddess of
# the
# Telephone

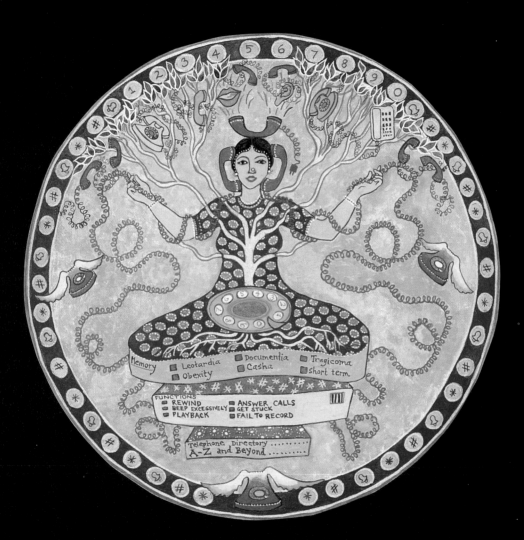

# Further Words from the Great Goddess on a More Serious Note

## Welcome back...

With the aid of Dialtonic and a bit of goddessification you've hooked into the Goddessline.

## Peace reigned...

Oh My Goddess! Values were different in my day. For a start, the people who worshipped me for all those centuries and over such a vast area were peaceful.

Heaps of paleolithic and neolithic remains have been unearthed without a speck of fortification or war-oriented paraphernalia to be found.

Doesn't that knock the grunting-hunting-fighting-cave-thug belief on the head?

## I left many clues...

I left the archaeologists, historians and other delving fellows many clues. But they had trouble understanding my significance.

I thought my clues were really obvious. Tens of thousands of sculptures in my image let on clearly and plainly how much I was revered. Later, people scorned these exquisite woman-made figures, or dismissed them as pagan fertility idols. Called them Venus (read "love-object") of Willendorf, Venus of this, Venus of that.

Saw them as a sign of men's early sexual fascination with women's bodies. Sort of paleolithic playboy bunnies.

# Sex . . .

Don't get me wrong. I like sex. And intimacy, love and creative, intellectual and spiritual fulfillment. I believe all of these are inextricably woven together into the Fabric of Life.

Sex is important. I should know. I started it.

# Women's power . . .

In the early days of my cultures people didn't even realize that men played a part in the creation of life.
Women were the ones who got full round bellies and produced new human beings.
Clearly, women, the miracle-makers, together with their bodies, were to be honored.

Another womanly power lay in the magical act of bleeding in time with the moon. Time measurement, astronomy, mathematics, geometry and agriculture grew from women's experience of bodily, lunar and seasonal cycles.
Menstruating women gathered in huts in reverence of their "wise wounds."
Blood rituals, amongst others celebrating women's mysteries, were later distorted into his-stories about menstruating women being dirty, wicked and witchy. They had to be segregated from everyone else. Beliefs like this shape modern woman's negative experience of her own menstrual cycle, although intensive goddessification with Fallopia should rectify this shameful situation.

In fact, today's woman contains my power within her. Immanent, not transcendent. This means Goddess power is to be contacted within.
The concept of a higher authority out there in the sky telling you what to do is a recent patriarchal one.

# Back to sex . . .

It was healthy to be sensual, to live in the body in the here and
   now, to attain pleasure from sex. And sometimes women bore
   human fruit.

However, these "fertility cults," as his-storians call them, did not
   focus exclusively on woman's amazing technicolor reproductive
   capacities.
My child-bearing form symbolized fertility of heart, spirit and mind
   as well as of body.

# Some stories . . .

Here's a story of one of my daughters, Athena. In pre-Hellenic
   times she was worshipped for her wisdom and creativity. She
   watched over spinners, weavers and potters.
Originally, Metis produced Athena in a good old-fashioned natural
   childbirth. Later, the story was changed so that Zeus, up and
   coming Olympian boss god, swallowed pregnant Metis and
   birthed Athena from his head.
Athena was born again as Goddess of War. The women's wisdom
   and arty stuff took a back seat. She became a power-dressing
   daddy's girl who betrayed her sisters.

So woman-of-woman's-body-born, which kind of makes biological
   sense, developed into woman-of-man's-head-born. Personally, I
   find that hard to swallow.

Even later, stories were told of a father sky god who created the
   world just by speaking. And of a woman, immaculate of concept,
   who played a supporting role in giving birth to His Son. These
   stories became known as "religion," other stories as "myth"
   and Great Goddess stories were "pagan rites" or "the Devil's
   work."

———

I've been told that this is the way it was:

Old Mr. God got the ball rolling in six days, with rest and recreation on the seventh.

Then man-the-hunter did his thing, with Mr. God's continued assistance, of course. A brave man in leopard skin trousers clubbed a pretty-but-helpless maiden over the head and dragged her by the hair back to the suburban cave.

Once married, the virgin transformed instantly into a plain-but-good cave wife and mother.

Nuclear Flintstone family bliss.

So man-the-hunter was freed up to chase mammoths, invent art and science, go out drinking with the boys and take on a mistress to satisfy that innate sexual urge which his woman allegedly did not share.

Elaborate imagination at work. Pity it's so untrue.

## Woman-the-gatherer . . .

For one thing, no culture in the history of the world has depended primarily on hunting for its sustenance.

Hunter-gatherer societies have relied on gathering for 80 percent of their food—"women's work." In any case, hunting was a community activity; not purely the task of the lone male hero.

The belief that everything of value in contemporary culture springs from man-the-hunter is incorrect.

Am I cynical? OK, Mr. God said and did some terrific things. But I've been treated badly by many of his followers.

## Of wholes and monsters . . .

Part of the reason the world's in a mess today is that somewhere around the time spiral, the sacred feminine was lost.

Look at this list (compiled with Documentia's assistance): woman and man, yin and yang, dark and light, below and above, nature

and culture, death and life, body and mind. All of these can be
recognized and accepted as parts of the whole.
This is preferable to splitting the whole into two bits, separating one
out, labeling it bad and then trying desperately to bury it away
out of sight.
What happens when you do that is that the "bad" bit refuses to
stay underground. It festers and swells and erupts in your face.
A death-denying culture is the very one that becomes plagued by
death, violence, war and fear of monsters of the dark.

Speaking of monsters, in my time, snakes and serpents represented
female sexual, mystical and prophetic power. You may be
familiar with the Cretan snake goddess, snakes entwined in
Hera's robes and on Athena's shield and Medusa's snake hair
writhing with female energy.

Heroic slaying of monsters of the deep is a direct metaphor for
patriarchy killing the Goddess religion.

Goddess destruction times were rife with tales like Perseus
murdering Medusa (with Athena's help), Saint George slaying the
Dragon and a sneaky snake wriggling around the Garden of Eden.

## Recycling symbols . . .

Did you notice the snakes and spirals in my family album?
My granddaughters recycle quite a few of my ancient symbols. Tran-
sit's Wheel of Fortune reinvents the wheel, Eronia wears the
sacred triangle as a heart, Sweepa cooks up a brew in a cauldron
and Dialtonic branches into the telephone tree of life.

You may have noticed some family resemblances, too. Obexity
looks remarkably similar to the Earth Mother of Willendorf.
Thorax takes after Native American Spider Woman. Pramh has
a lot of the Maltese goddess and a touch of the Virgin Mary in
her blood. Dialtonic resembles the Cretan snake goddess,

Fallopia brings to mind Venus standing on her shell and Electra sizzles with the energy of a dark goddess of the underworld.

## Devolution . . .

Goddess worshipping cultures thrived for at least 25,000 to 30,000 years, over a wide expanse of Europe and the East.
The attempted overthrow began around 4,500 B.C.E.
Warring nomadic patriarchal tribes invaded from Northern Europe.

The suppression of the Goddess world view did not happen overnight, but gradually over many thousands of years.
First, there were successive waves of invasion.
Many of my temples, sacred places and statues were ruthlessly destroyed.

The violence against my cultures did not arise out of dissatisfaction from within, but from aggressive outsiders with their own beliefs.

My followers were persistent. In many places they carried on ritual worship and celebration regardless.
Sometimes the invaders had to think up ways of winning over Goddess worshippers. My stories were reconstructed. Rites and symbols were incorporated and taken over by new religions.

For instance, after a good harvest I was lavished with bread and wine offerings——fruits of the earth returned to the Earth Mother. Later, bread and wine symbolized the body and blood of the son of the sky god. Both Christmas (at Winter Solstice) and Easter (early Spring) originate in Goddess celebrations in tune with lunar and seasonal cycles.

## Many Gods and Goddesses . . .

My powers were fragmented and dissipated. In places like ancient Egypt, India and Greece, instead of one all-powerful Earth

Mother Goddess, there were many gods and goddesses. The gods assumed more importance, the goddesses less. Women's power in society also diminished.

In ancient Greece, Olympian gods and goddesses emerged from Gaia the Earth Mother. My powers were split into different portfolios carried by some of my daughters such as Aphrodite, Goddess of Love and Demeter, Goddess of Plenty.

Hestia, Goddess of the Hearth was initially the most widely worshipped of the Olympians. Every home had a Hestia shrine. With the shrinking of her (and my) power, things changed. She was demoted and replaced on Mount Olympus by Dionysus, boy god of wine, women and ecstasy.

Eventually, religions emerged with one all-powerful, omniscient and often punitive father sky god.
The devolution of Goddess power continued with the Crusades and the witch burnings—otherwise known as the Women's Holocaust. Nine million people, mainly women, were tortured and killed as witches over 300 years.

## I'm still around . . .

Fragmentation, dissipation and distortion of my energy continued into the present day, but my essence has been kept alive.

From the Goddess Healing to Acuppa, Goddess of Tea.
From the Goddess of the Earth to Thorax, Goddess of Pest Management.
From the Goddess of the Hearth to Sweepa, Goddess of Housework and Purity.

Diminished and scattered my spirit may be, but my girls keep me going.
Remember, I am alive and well and living in YOU.